POCKET GUIDE
to
Calligraphy

This edition published in 2021

Search Press Limited
Wellwood, North Farm Road,
Tunbridge Wells, Kent TN2 3DR

First published as *A Guide to Calligraphy*
by William Mitchell Limited
Copyright holder © William Mitchell Ltd., 2021

Design by Chris Griffin
Design copyright © Search Press Ltd., 2021

ISBN: 978-1-78221-815-9
eBook ISBN: 978-1-78126-785-1

The Publishers and author can accept no
responsibility for any consequences arising from
the information, advice or instructions given in
this publication.

Readers are permitted to reproduce any of the
examples in this book for their personal use, or for
the purposes of selling for charity, free of charge
and without the prior permission of the Publishers.
Any use of the examples for commercial purposes
is not permitted without the prior permission of
the Publishers.

Suppliers
If you have difficulty in obtaining any of the
materials and equipment mentioned in this book,
then please visit the Search Press website for
details of suppliers: www.searchpress.com

POCKET GUIDE
to
Calligraphy

Joy Daniels & Nicola Dunn

Search Press

Calligraphy

Contents

Introduction

This book is designed to help you take your first steps into the art of calligraphy. It is an introduction to basic hand lettering techniques, and will explain what the key terms are and mean. You will then be introduced to and shown how to write four different, classical alphabets.

Don't try to do everything at once – calligraphy takes a lot of patience and practise! At first you will need to look at each letter carefully, and make a note of the number of strokes necessary and their direction; in time, you will become more familiar with the shapes of the letters.

Once you are confident writing with a fountain pen, you can progress to using a dip pen with bottled inks or a special paintbrush and gouache paint. The best thing to do alongside your practice at home is to find a calligraphy class where the teacher will be able to support your learning and show you what (and what not) to do. There may also be a local calligraphy group, so that you can get together with like-minded people to share your hobby. It's always fun to learn with others!

Brief history
of calligraphy

The alphabet we are all familiar with today was adapted from the Greek alphabet by the Romans over 2,000 years ago. The shapes of the letters have gone through many changes in style, but the classical Roman capitals are the basis of all calligraphy and letter design.

Throughout history, the tools and materials available have influenced the formation of the letters – from reed pens used on rolls of papyrus, quill pens used on vellum, through to the metal nibs and fountain pens used on smooth paper today.

Until the invention of printing, all manuscripts were written by hand. As a result, many styles of writing evolved over time and in different locations. Exquisitely beautiful books were produced in the Dark Ages by scribes in monasteries – the Lindisfarne Gospels and the Book of Kells are wonderful examples which survive to the present day.

The quill pen, cut from feathers, was the writing instrument in use for the longest time – over 1,000 years. Quills were eventually overtaken by metal dip pens, fountain pens and all the different pens available today.

Modern interest in calligraphy can be traced back to the early twentieth century, when Edward Johnston rediscovered the use of the broad-edged nib. He studied the tenth-century Ramsey Psalter – a famous, beautifully illuminated book of devotional text from the Anglo-Saxon period – and developed a new version of this script, known as Foundational Hand. Through him began a revival in calligraphy that has grown and developed into the fine art form you see today.

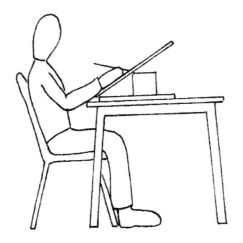

Diagram 1

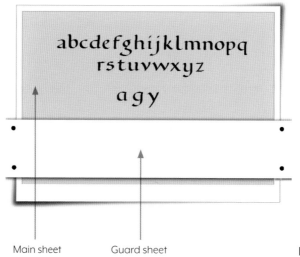

Main sheet Guard sheet

Diagram 2

Getting started

Letters are usually made in more than one stroke of the pen. Each letter in this book will have a series of arrows and numbers around it, indicating the number of strokes needed to create the shape and the direction to draw each stroke. Take careful note of these as they are there to help you. Start with the first stroke and move the nib in the direction of the arrows. At first you will have to keep referring to these instructions, but with practice you will get to know the shapes of the letters and start to write more freely.

Sit comfortably at a table with your feet flat on the floor (see diagram 1, opposite). Use a board of some sort, propped up at the back with some books to create a good, angular surface to write on. Writing with your paper flat on the table is not a good idea, as the pen will not flow well and you may get backache.

Tape a 'guard sheet' onto your board, over your hand-lettered sheet; use this to rest your hand on as your write, as this will keep your main sheet clean (see diagram 2, opposite).

Try to write whole words rather than just single letters as this will help you get used to letter spacing as well. It's not a good idea to try to get one letter perfect before moving on to the others!

PAPER
For practice, any smooth paper is adequate. Be prepared to use a lot! Photocopy paper is perfectly good for practice.

PEN ANGLE

The angle at which you hold the pen is important to create the correct shapes of the letters. Each alphabet is written with the nib at a particular angle. For example, in this book, Foundational is written at 30 degrees, Italic 45 degrees, Uncial 20 degrees, and so on. The characteristic shapes of each alphabet will be made with the nib held at this angle throughout.

The angle you hold the nib is important, as it will give you the width of the down stroke. Each alphabet will have a diagram to show you at which angle to hold the nib. Check the tops and bottoms of your letters to see if you have the correct angle and if you are being consistent. If the downstrokes in your alphabet all look the same width you are holding the pen correctly.

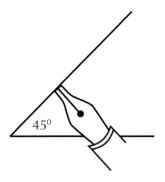

The steeper angle gives a thinner stroke.

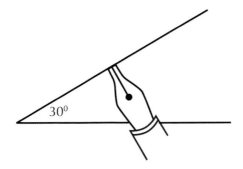

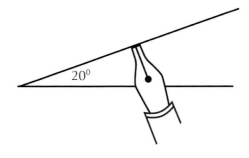

This flatter angle gives
a wider stroke.

NIB WIDTHS EXAMPLES

3 nib widths

4 nib widths

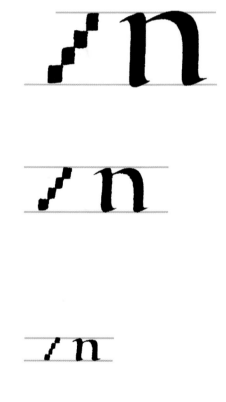

'x' height

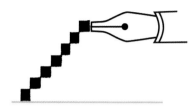

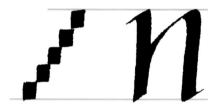

5 nib widths

NIB WIDTHS

This simply means the width of the nib you are using, and can be measured by holding the pen sideways and making a little mark with the ink. This is the only time the pen is held like this – it is a way to calculate how big the letters should be for each nib.

If an alphabet states '4 nib widths', you make four small sideways marks with the pen so they just touch each other on the corners. You then measure from top to bottom; this measurement will give you the size of lines to draw for that particular nib – this measurement is called the 'x' height. Most of the small letters will fit within these lines, but some letters have parts which are taller (called 'ascenders') – such as 'd' and 'b' – and some have parts which go below this line (called 'descenders') – such as 'g' and 'y'. The 'x' height lines are the most important ones to draw within, because it will make your writing look nice and regular, even if one or two letters have parts that extend beyond them.

The nib width calculation works for any size nib and will make everything the right proportion. The bigger the nib, the bigger the letter. Some alphabets might be 5 nib widths and some only 3. An alphabet with 5 nib widths will appear taller and one with 3 nib widths will appear fatter and wider. The number of nib widths is always indicated on the instruction page. You will be able to find more information about this on video sharing platforms like YouTube™.

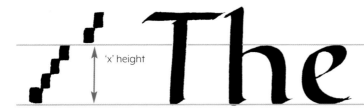

'x' height

Base line

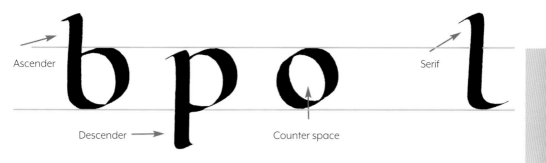

Ascender

Serif

Descender

Counter space

EXAMPLE GUIDE LINES

Each alphabet will state how many 'nib widths' tall the 'x' height should be, and the ascenders and descenders, so for any size nib you use, you will need to measure the nib widths and draw some guide lines to write in between. Make sure your pencil has a good point. If you would like more guidance, you can also look on the William Mitchell website (www.williammitchellcalligraphy.co.uk) for information on measuring guide lines. You will also be able to find useful instructions in technique videos online.

SPACING

The spacing of each letter is important to make your writing look even. Try to be aware of the white background space as well as the black shapes you are writing.

A good basic rule for spacing is that there will be the most space between two straight strokes, the least space between two round letters (because of the counter space inside the letters), and somewhere in between for a straight and a rounded letter.

Some alphabets can have tighter spacing, such as Gothic Hand, whereas Foundational Hand needs fairly generous spacing.

Write some words, then stand back and look at the page – if there are some areas which appear darker, then the letters are a bit too close. The size of the 'o' of the alphabet should fit between each word.

When you are ruling your lines, allow enough space between the lines to avoid clashes between the ascenders and descenders.

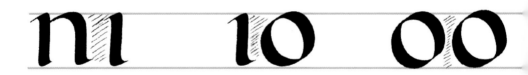

too close ✕

too far apart ✕

better spacing ✓

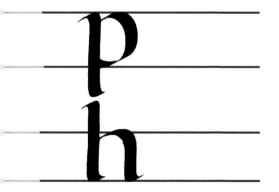

Foundational Hand

Foundational Hand is a basic, classic hand developed by Edward Johnston in the early part of the twentieth century, from his studies of the round Carolingian script seen in the tenth-century Ramsay Psalter. It is a plain and clear alphabet, formal and well proportioned, and a good basic alphabet with which to start calligraphy.

The form: this upright alphabet is based on the circle, and all the letters relate to this shape and its dimensions.

The angle: the pen is held at an angle of 30 degrees – although there are some angle changes, for example diagonal strokes are made at a slightly steeper angle.

The height: the 'x' height is 4 nib widths

The sequence: most letters are made of two or more pen strokes – follow the arrows to see the number and direction!

∠30° Foundational

Letter shapes to practise

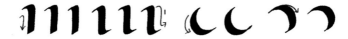

The 'i' and over arches

i in inm lh

iaa ir lk

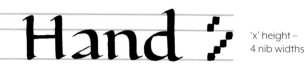

Hand 'x' height –
4 nib widths

Circular letters

co lb ipp

cd ccgg

ccq cce

cogg

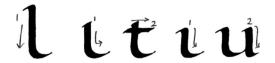

Foundational

Underarches and related curves

l l t l u

Flattened curves top and bottom

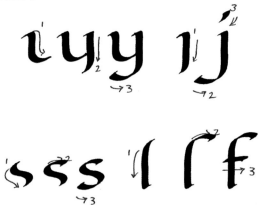

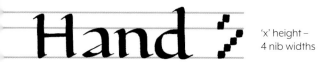

'x' height –
4 nib widths

Diagonals

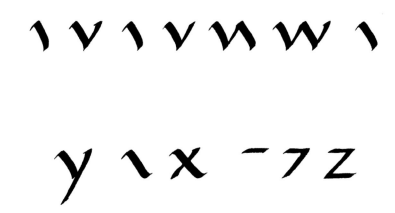

Foundational

'x' height –
6 nib widths

Narrow letters

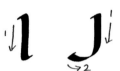

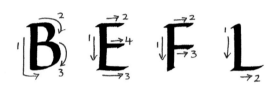

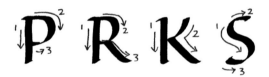

Wide letters

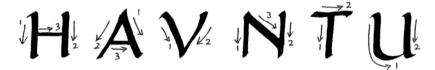

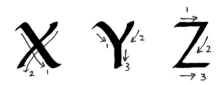

Capitals

Circular letters

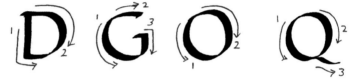

Extra wide letters

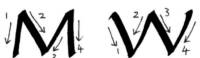

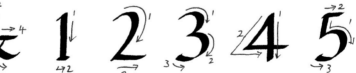

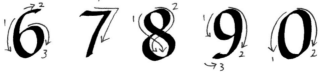

Foundational

abcdefgh

ijklmnopq

rstuvwxyz

Alternative letters

agy

Hand

ABCDEFGH

IJKLMNOPQ

RSTUVWXYZ

Foundational Hand

Joyeux Anniversaire

Happy Birthday

Feliz Cumpleaños

xyz

Italic Hand

The Italic Hand was developed in Italy during the Renaissance – hence its name. It was based on the earlier Carolingian hand; as it was written more quickly, a forward slope developed.

The form: this alphabet is based on an oval, and all the letters relate to this shape and its dimensions. It has a slight forward slope.

The angle: the pen is held at an angle of 45 degrees – although there are some angle changes for diagonal strokes.

The height: the 'x' height is 5 nib widths – so it will appear taller and thinner than the Foundational Hand.

The sequence: a lot of the letters can be written in one stroke, but some are made up of two or more. Aim for consistency in your writing – straight parallel strokes and asymmetrical arches.

ITALIC CAPITALS

The Italic capitals are 7 nib widths tall. Ascenders are taller than the capitals.

Italic capitals are very similar to the Foundational Hand capitals – just a little taller and slimmer, and with a slight forward slope.

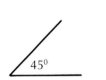

The Italic

Pen exercises

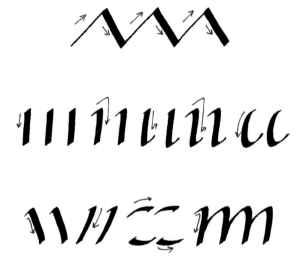

Over arches clockwise based on 'n'

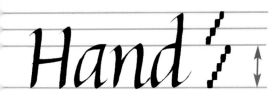

'x' height –
5 nib widths

Oval based on 'o'

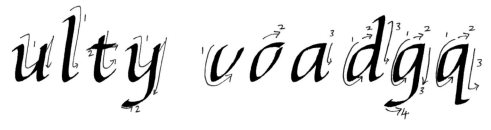

Under arches anticlockwise based on 'u'

Flattened tops and bottoms

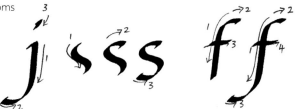

Diagonal – flatten the angle of the pen for
strokes in this direction

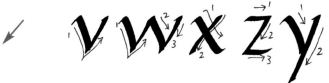

33

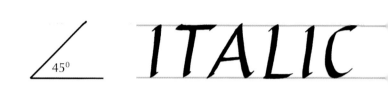

Narrow letters

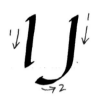 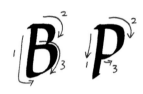

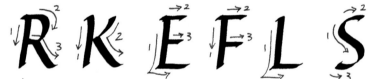

Wide letters

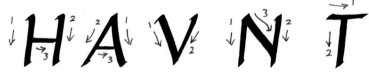

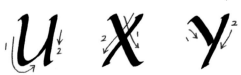

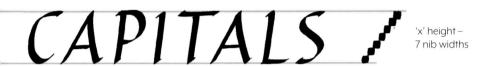

'x' height –
7 nib widths

Oval letters

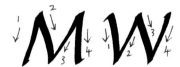

Extra wide letters

abcdefghijk
lmnopqrstu
vwxyz

1234567890

ABCDEFGHIJK

LMNOPQRSTU

UVWXYZ

Joyeux Anniversaire

Feliz Cumpleaños

Happy Birthday

Uncial Hand

Uncials are capital (majuscule) letterforms which developed from Roman Capitals and led to the development of a small letter (minuscule) alphabet. Before this there were only capital letters.

It was used widely between the fourth and eighth centuries, and there are many variations. This version is based on the Stonyhurst Gospel of St John written around 698AD.

This alphabet stands alone, but if you want to emphasize a first letter it can be written with a larger nib, or just drawn a bit bigger than the rest of the letters as in the examples on the following pages.

The form: based on the 'o' form, slightly wider than a circle. Upright with rounded arches and small round serifs.

The angle: pen held at an angle of 20 degrees for all strokes except diagonals in v, w, x and y which can be steeper.

The height: the 'x' height is 3 nib widths, so it will appear squat and bold. There are only a few very minimal ascenders and descenders.

The sequence: an average of three strokes per letter. The order and direction is indicated by numbers and arrows.

Spacing: generous – to balance the large areas of space held within the letters.

Pen patterns

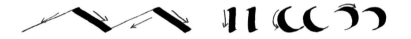

Wrong pen angles –
first is too steep, the second too flat

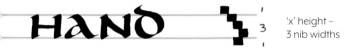

'x' height –
3 nib widths

Round letters based on the 'o'

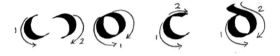

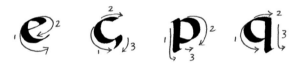

Straight letters
No dots on 'i' and 'j'

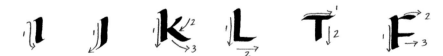

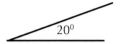 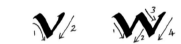

THE UNCIAL

Diagonal letters –
flatten pen angle on diagonal stroke of 'z'

Two tier letters

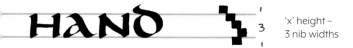

'x' height –
3 nib widths

Alternatives

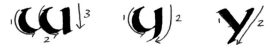

a B C D e F G

H I J K L M N O

P q R S T U

V W X Y Z

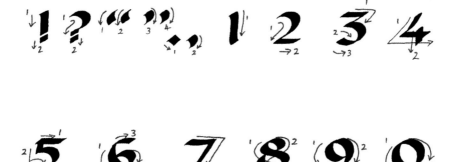

Example of enlarged 'capital' letters

NEW HOME

CONGRATULATIONS

WELL DONE

BONNES VACANCES

Gothic Hand

Gothic Hand, or Gothic Blackletter, is a decorative and distinctive script which developed between the twelfth and fifteen centuries, through gradual compression of rounder scripts. Many variations evolved, some more angular than others, and was used widely in northern Europe. This form is based on a Textura script from around the middle of the Gothic period.

The form: this alphabet is based strongly on the flat sided 'o'.

The angle: the pen is held an angle of 45 degrees.

The height: the 'x' height is 5 nib widths with short ascenders and descenders (2 nib widths) – the angular serifs make the overall script appear heavy.

The sequence: very repetitive sequence of strokes with a lot of pen lifts, which makes it slow to write.

The spacing: upright and even – quite close together to create a textured and patterned appearance.

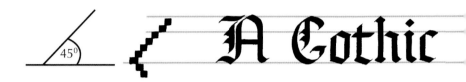

Pen patterns for component
parts of all letters

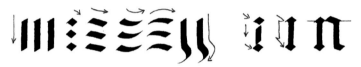

Diamonds and lozenges align

Push pen forwards
and backwards

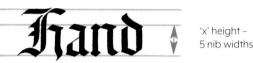

'x' height –
5 nib widths

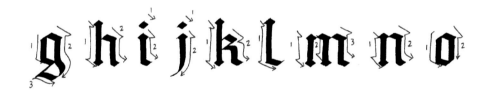

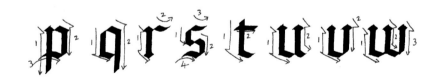

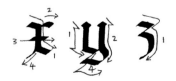

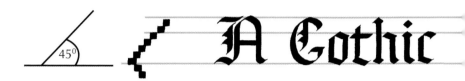

Alternative letters

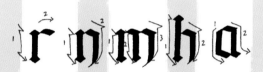

All letters are based on the 'o'. Straight, vertical strokes start below the top line and stop before the base line to allow for additional strokes

abcdefghi

'x' height –
5 nib widths

jklmnopqrs

tuvwxyz

Gothic Capitals

All first strokes start a little below the top line.
If it is a straight, vertical stroke it stops short of the
base line to allow for joining strokes

Additional pen
movements

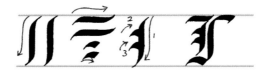

'x' height –
7 nib widths

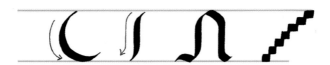

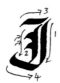
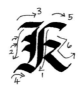
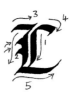

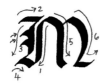
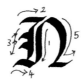
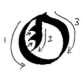

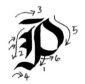 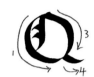

 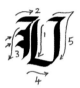 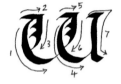

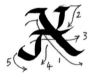 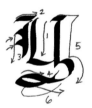 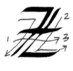

A B C D E F G

H I J K L M N

O P Q R S T U

V W X Y Z

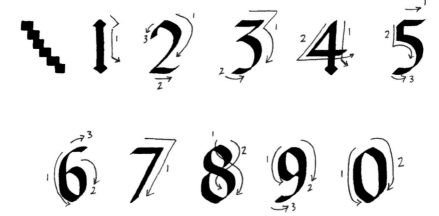

Season's Greetings

Joyeux Noël

Feliz Navidad

Shopping list

- Fountain pen ink and/or ink cartridges
- Paper, for practising – smooth photocopying paper or lined paper is adequate
- Medium pencil for drawing guide lines
- Pencil sharpener
- 30cm (12in) ruler
- Eraser
- Fountain pen or round hand dip pen nib (a left oblique nib pen available for left-handers).

You have made your first steps into the wonderful world of calligraphy! Don't be put off if you can't write every alphabet in this book – to start with, concentrate on the one you find the easiest; once you have gained some confidence, try another one.

Not everyone can write every style equally well. There are many more styles of writing which you could go on to learn, perhaps in a class or a calligraphy group. You can progress to using dip-in nibs and gouache paint for colour work, and using better quality papers to produce finished pieces of work with professional results.

Good luck and happy writing!

About the authors

JOY DANIELS

Joy's first introduction to calligraphy was during a weekend course at the Bluecoat Chambers in Liverpool, UK in 1979. She thought it was the best thing ever, and has been completely hooked on pen lettering ever since!

Initially, Joy was mostly self-taught with a bit of help here and there. Her interest in lettering got her a job as a poster writer at a silkscreen printers in Northampton, UK during the 1980s, when price tickets, posters and banners were handwritten or hand-painted. Joy then officially became self-employed, painting and writing letters for several companies. At the same time she studied part-time, gaining a qualification in Signwork and training as an Adult Education tutor at City & Guilds in London. As computers steadily took over the production of posters, Joy continued to use her talents commercially on a smaller scale, creating personalized hand-lettered designs for official documents and events, along with other calligraphic commissions.

Today, in between commercial and commissioned work, Joy likes to further her study of calligraphy by attending other tutors' workshops whenever possible, and travelling around the country teaching hand lettering for regional calligraphy groups. She also runs a weekly class in Northampton, UK (now in its fourteenth year), combining calligraphy with hand-made cards, little books, boxes and special keepsakes to encourage students to create beautiful things with their lettering. It gives Joy great pleasure to bring out the creativity in others, especially people who think they're not 'artistic', and she always encourages her fellow calligraphers to share ideas and to give and receive encouragement. Joy enjoys learning and teaching – and always will!

www.joydanielscalligraphy.co.uk
Facebook – Joy Daniels Calligraphy
Instagram – Joy Daniels Calligraphy

NICOLA DUNN

The alphabet always fascinated Nicola as a child, but it was 20 years before she realized it was called calligraphy, and that it was something you could study. While she worked full time during the day at design studios for magazines, at night Nicola pursued her fascination for lettering and attended evening classes for over 10 years. When she moved away and had to change jobs, Nicola jumped at the opportunity to take an NVQ in Training and Development, which enabled her to teach her passion. One calligraphy class quickly became four, and soon she was teaching calligraphy at beginner and intermediate levels, and at the craft courses within the Design Core unit for City & Guilds.

As she taught, Nicola also joined and began attending workshops run by The Society of Scribes & Illuminators (SSI) in London; she also set up a regional calligraphy group in Northamptonshire, UK, where eminent calligraphers were regularly invited to share their expertise and range of styles. Inspired by the work of the talented calligraphers around her, Nicola was encouraged to enrol in the three-year Advance Training Scheme run by the SSI. After years of encouraging others to explore their creativity, this was a chance for her to examine her own and, with excellent critique along the way, perfect her lettering style.

Since moving back to London 12 years ago, Nicola now uses her skills commercially – from creating personalized designs and stationery for large-scale events to bespoke hand-lettered keepsakes for individual clients. She is also a member of a regional calligraphy group based in London, where she regularly organizes workshops and courses with a range of tutors. For Nicola, the learning process for calligraphy continues and she expects will never stop – the joy of picking up a pen and doodling for fun, over the many years of working on her craft, is still undiminished.